Dancers

Dancers

Photographs by Annie Leibovitz

Smithsonian Institution Press, Washington and London

Published in association with Constance Sullivan Editions

This series was developed and produced for Smithsonian Institution Press
by Constance Sullivan Editions

Editors:
Constance Sullivan
Susan Weiley

Smithsonian editor:
Amy Pastan

Designed by Jeff Streeper
Series design by Katy Homans

First edition

Printed by Meridian Printing, East Greenwich, RI, USA
Duotone separations by Thomas Palmer
Photographic prints by James Megargee
Cover: Mikhail Baryshnikov, Brussels, 1990

For my mother, my first dancer

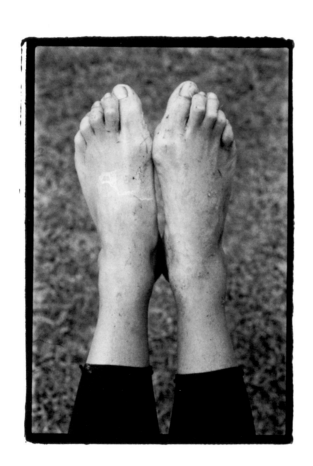

Marilyn Leibovitz, Ellenville, New York, 1974

Much of the work you did in the 1970s for *Rolling Stone* magazine was taken from real life, unposed, and shot in black and white with natural light. Your portraits have become more preconceived and stylized. They are usually set up, using strobe lighting with heightened, theatrical color. Can you talk about that transition?

I prefer to work on location rather than in the studio, and a lot of the set-up work is actually done outdoors because I like mixing strobe light with ambient light, particularly for color photography. The studio is not the most comfortable place for me because I came out of reportage, and that's the style I brought to the early work for *Rolling Stone.*

The first photography books I owned were *The World of Henri Cartier-Bresson* and Robert Frank's *The Americans.* The idea of photography I started with was all about being there at the right moment: having an eye, seeing something, and photographing what was going on in front of me without interfering with it. I still like to use the window of the camera as the frame and very rarely crop my pictures, whether I'm using a 35mm or a larger-format camera.

It's easy to look back now and say that I had a personal eye when I started working for *Rolling Stone.* But you don't know you have a point of view when you're so young. You pick up the camera when you feel moved to do so, when you see something that you think is a photograph. During those first two or three years at *Rolling Stone,* I thought of myself as a journalist. I loved the photographs of Margaret Bourke-White and Eugene Smith, and when you looked at *Life* magazine you saw Larry Burrough's pictures taken in Vietnam and thought about that kind of work.

The first photographs I brought to *Rolling Stone* were of an anti-war rally. I had taken them the day before and I think they were really taken aback that I had processed and printed my film so quickly. They weren't used to getting something turned in so fast.

You were twenty years old.

Yes, and I was in my third year at the San Francisco Art Institute.

Was it unusual for them to publish the work of a student?

Well, back in 1970 the people running *Rolling Stone* were themselves a bunch of kids. The magazine was only two years old and not yet distributed nationally. They used publicity photographs and pick-up photographs because they usually didn't have the budget to assign a photographer to a story. Baron Wolman had been taking pictures for them but he decided that he was more interested in starting a magazine of his own, so they needed somebody and I walked in at the right time, and they started giving me things to do.

When did you start to make the portaits of famous personalities that you are known for?

I began doing those sort of pictures when I was asked to do covers for *Rolling Stone.* And doing covers inspired me to do more and more conceptual portraits. In the late 1970s I photographed Steve Martin against a Franz Kline painting, I did Bette Midler in the roses, even the photograph of John and Yoko was first an idea. After I went to *Vanity Fair* in 1983, I began to do large head shots for the covers. I began to explore the landscape of the face.

What are you recording in your pictures? What makes a portrait meaningful or powerful for you?

Well, first of all, a photograph should be memorable. It should be formally interesting. And I like it when someone is touched by one of my photographs. What drives me is that my photographs are part of a body of work. They span a period of time, and you see the time reflected in the work. When I saw Lartigue's book *Diary of a Century,* which Bea Feitler designed, I was impressed that those photographs were taken over a whole lifetime.

The cumulative effect of your recent book *Photographs 1970–1990,* is a kind of documentary portrait of our time.

At first I was reluctant to organize the work chronologically, because I did not want people to think of it as a history book. Obviously, I didn't photograph every president. And where are Jimi Hendrix and Janis Joplin? They both died the first year I worked for *Rolling Stone.* But when I first laid out the pictures in the studio and sequenced them chronologically as a starting point, what emerged was the photography. The book collects my most memorable shootings and my favorite photographs. They give a feeling of the time. And that was even more from my style of work than from the people in the photographs. It all works together.

The pictures you chose to reproduce show that you don't have one style or approach to photographing people.

You can't use the same technique or style with everybody. For instance, I wanted the formal quality that working in the studio brings when I photographed Jessye Norman. And the dance work was shot in black and white with natural light because I felt it expressed the emotion of dance. In fact, the last few years I've been relearning natural light, after doing so much strobe work. I decided to shoot Peter Matthiessen—who is not ony a writer but a Zen master—in black and white, very small against the vine-covered house that he writes in. But when I recently shot the performance artist Karen Finley, I thought in color. I did it in Fujicolor, which is very artificial looking, a bit like old-fashioned Technicolor. Sometimes I want a more natural feeling. Other times, a more controlled effect is what's appropriate for the person I'm photographing.

What about the picture of Whoopi Goldberg in a bathtub full of milk? Did you decide beforehand to photograph her that way?

I photographed her as part of a series for *Vanity Fair* on young, upcoming comedians. This was before Mike Nichols directed her on Broadway and before she did the Steven Spielberg film "The Color Purple." I had seen two or three of the others perform live in small comedy clubs, but I hadn't seen her, so Whoopi sent me a badly done video of one of her acts. I could barely make her out on stage, it was so poorly lit. At the end of this tape she played a little black girl trying to scrub her skin white and I imagined her doing this in a bathtub. Then I found out that milk photographs very white, so we heated gallons of milk and put it in the tub to make a warm milk bath. When she slipped into the milk, something happened that I didn't expect. She went deeper than I expected her to. Only her face was showing. She played with the element of the warmth, and she completely relaxed. And the picture that came out of this was even stronger than I had imagined.

So even though you prepare and plan for a shooting, things sometimes happen that you don't anticipate.

Yes. That's the dream shoot. I want to be ready, with two or three good ideas, so that something else, even better can happen. But I have to start somewhere. Sometimes I suggest an idea to the subject, hoping to move or inspire them or that they will get involved. And I can't tell you how many times I've gotten a bad idea from someone and it made me think of a good idea. Of course, the ideal situation is when I have a collaboration with someone like Diane Keaton, who is also a photographer and film-maker and is used to being on both ends of the lens and loves to talk about whether the picture should be in black and white or color. That's the most exciting thing for me. It's a far cry from when I stayed on the outside, like a journalist watching a situation unfold, to the way I feel now, which is that the more my subjects are involved the closer I will come to making a good portrait of them.

As much as I plan my conceptual work, I still hope for something unexpected. In magazine work particularly, I can't count on things happening naturally or spontaneously. I have to be prepared. Some of the more controlled work came out of the fear of there not being something there when I arrived, or that the subject would show up and say, "Well, what are we going to do?"

Do people expect you to make them look a certain way?

Yes, they often do. And I love to show them something new about themselves. I remember when I pulled the Polaroid of John Lennon and Yoko Ono, and John looked at the Polaroid and said, "That's us. That's our relationship." That was a very touching moment for me.

John Lennon was killed that same day.

Yes, he was murdered a few hours later.

And that adds to the meaning of the photograph.

It's the nature of photographs to accumulate meanings. Photography is really a lucky medium in that time is kind to it: a photograph only gets better, more interesting, with time. A photograph from 1910 or 1920 of a car going down the street or of a horse is fascinating because it's a document from that time, and the elements in the photograph as well as the technique make it interesting. But with the Lennon picture all those responses to a photograph that normally happen over a period of time were speeded up. Because he was murdered that night all those feelings were heightened and there suddenly were about fourteen more layers to deal with. It's amazing what time or an event does to a photograph, how it changes the way you look at it.

Over the years, the way you light your photographs has changed. When did you go from natural light and black-and-white photography to the color work that you light with strobes?

In the early years at *Rolling Stone,* I was intimidated by color. Color film is slower speed and to get an image that would reproduce well in the magazine, which was printed on coarse rag paper, I had to start lighting my subjects. The strobe work evolved from trying to survive their printing process. With rag paper the ink sinks into the paper and the picture prints off-register. I learned that the color had to be lit to create the contrasts I wanted. And as soon as you light, you need to have people in a fixed position. That's how the work started to become more formal.

At the beginning, I didn't have the luxury of telling my subjects when I could photograph them—they told me when I was supposed to show up. A lot of the early work for *Rolling Stone* was done when people passed through town. Lighting meant carrying around my own sun, so I lit everything up. I carried around one 400-watt-per-second pack. It became even more sophisticated when I started using generators and 2400 and 3200-watt-per-second Balcar packs. Now, when possible, I like the look to be more natural. I use a strobe just to clean up the shadows and saturate the color. This past year I've been working with 400-watt-per-second battery-powered Normans, which I prefer to carrying around generators and big lights.

You photograph famous people. How important to these portraits is the identity of the person being photographed?

There are times when the person is powerful enough to make the photograph. Some people are photographic, they lend themselves to being photographed—like Mark Morris, for instance, who is not only a genius but is so sexually charged and energetic. His total belief in himself is thoroughly projected at all times.

How is photographing a dancer like Mark Morris different from photographing a great film actress or powerful politician?

One of the reasons I'm interested in photographing dance is the completeness of the way dancers use their bodies. In turning to dance I was developing a way of working out some ideas about the nude and the expressiveness of the body. A dancer is the ideal subject for that. Most of my portraits had been of the whole body rather than just the face or head.

And that eventually led to your interest in photographing dance or the nude?

You know, until I went through the process of selecting the pictures for my book *Photographs 1970–1990,* I wasn't aware of how much I had been photographing the body—going as far back as 1973, when I photographed Divine backstage in his dressing room. I was interested in his environment. But, inevitably, it was his body that was the strongest element in the picture. The taste I had from the beginning for photographing people in full figure probably comes from the fact that I started with the journalist's point of view. When you do journalism, you want to get an overall shot of a scene. It's more of a story.

Does the fame of the person you are photographing influence the way you work or relate to the subject?

The fame is not as important to me as what the people are about, what their minds are like, and what they do with their talent. Certain people have a special relationship to the camera that cannot be underestimated. It's because of who they are within themselves.

Do you ever photograph people you are not at all interested in?

I do. And sometimes I'm surprised at what turns out to be a good photograph. You can't really tell until you get there. I'm curious about people and most of the time I want to like people; but the truth is we can't always like people and, especially in magazine work, I am prepared to photograph someone I don't like. Of course, I can show that I don't like them by how I take the picture. For example, when Arnold Newman photographed Krupp, the German armaments manufacturer, he made him look ghoulish by lighting him from below. As a portrait photographer, one must be open for any signal and be ready to take the picture.

What kind of give-and-take has to go on between you and your subject to make a shooting successful?

That's such a big question. Maybe we should talk about a specific example.

Let's talk about the dancer David Parsons. Why did you photograph him?

I had seen David Parsons dance with the Paul Taylor Dance Company. Then he left to start his own small company and to choreograph as well as dance. He did one dance called "Strobe," which is almost an homage to photography. He's on stage and the strobe light goes off and there's a moment of darkness and then he's lit again. He does at least twenty or thirty jumps, and each time the light goes on he's up in the air and in a different part of the stage. It's astonishing. The first time I photographed him, for the portrait series I did for the Gap, I put him in a suit and tie and shirt and let him jump. It was a wonderful shooting, but I saw the potential of something else and we promised each other that we would work together again. He did a lot of work with Lois Greenfield, who is a wonderful dance photographer, and I could tell when we did the Gap shooting that he understood what a photographer is looking for—he didn't just keep moving and dancing. The photograph is about moments, a specific split second, and he gave me split seconds rather than continuous motion.

Meryl Streep once came into the studio. Now she doesn't like to have her photograph taken. Actually, most great film actresses or actors are uncomfortable being photographed because they are used to being in movement—stopping or being stopped or staying in one place feels unnatural or awkward to them. Meryl and I had worked together on several occasions. We had done covers for *Vogue, Life,* and *Rolling Stone,* and I think this was a cover for *Vanity Fair.* When she was in the studio I said, "Go ahead and emote, go through a range of emotions on your face, as if you were in front of a motion-picture camera." She did. When I got the film back I couldn't cut it up. There wasn't one moment, one still, that felt like what was going on.

In the summer of 1990 you photographed the White Oak Dance Project, a collaboration between Mikhail Baryshnikov and Mark Morris, and spent several weeks with the company. How did that experience differ from the way you usually work?

What was interesting about the White Oak shooting is that I had the opportunity to document the process of dancers working on dance, which I thought was more successful than my formal portraits of the dancers. When you photograph dance, you have to find a moment that expresses the feeling of the dance, and it's not necessarily something from the dance nor is it standing still. I think the reportage of the dancers working together over three weeks was very strong and it was wonderful to be the only photographer in a room with nine dancers, watching them go through their day.

These photographs were an important step toward the David Parsons shooting, which happened almost a year later. As beautiful as the jump photographs were, I'd seen something like them before. Everyone knows that David's a big powerful jumper. But his work at that time wasn't only up in the air: it was closer to the floor, because

he was trying to move into a new place in his choreography and in his dance. He was working a lot with contorting himself. He has such a magnificent body that I wanted to photograph him in a beautiful way. I thought I didn't like his contortions. But then I started to see these movements as having something to do with the struggle in his life. He had just left Paul Taylor and was starting off on his own, which was a very brave and risky thing to do and I admire him for it. I had a Polaroid back on the camera as he started to crawl across the floor. I shot the photograph and pulled the Polaroid. That photograph of him crawling on the floor was a breakthrough for me. I think it was a new kind of dance photograph.

The White Oak Dance Project is similar to your photographing the 1975 Rolling Stones tour, inasmuch as you spent an extended time with both groups.

Emotionally it was very satisfying to spend a period of time with a group of dancers. It's not like photographing a band of rock stars or musicians. Dancers are very disciplined. A dancer is someone who knows how to listen to direction. And it was wonderful to work with this group of marvelous, experienced dancers from different companies who came together for the White Oak Dance Project. Working with each other, they were discovering something new about their possibilities as dancers. Working with them, I was discovering something new about my possibilities as a photographer.

Peter Martins and Darci Kistler, New York City, 1992

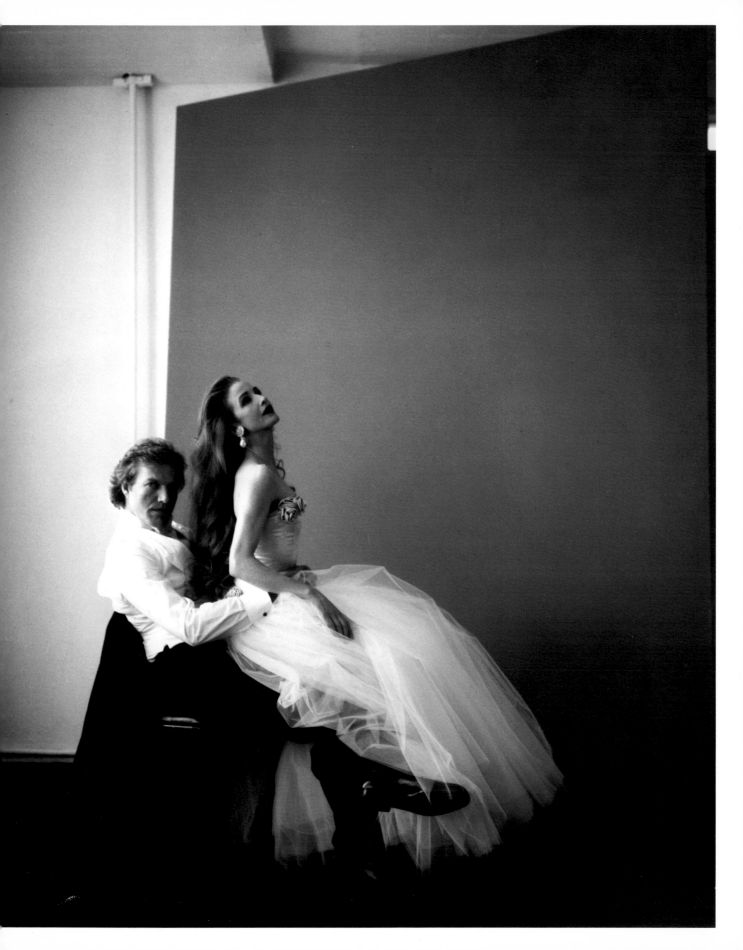

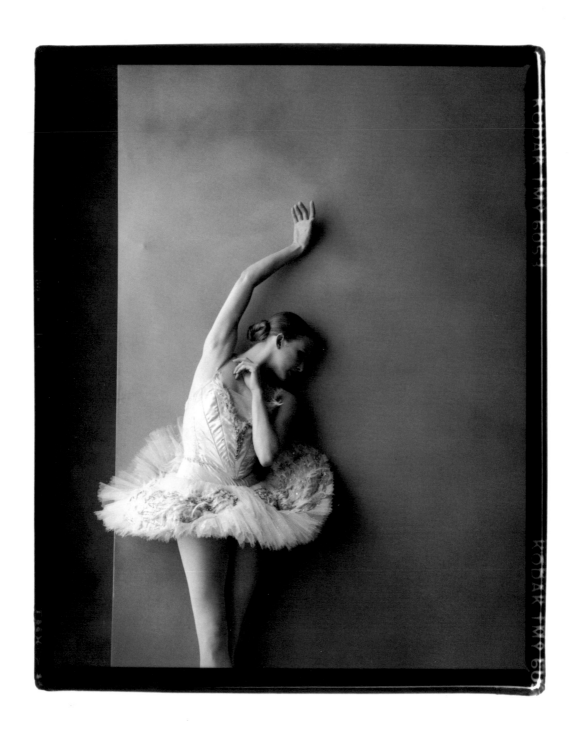

Darci Kistler, New York City, 1992

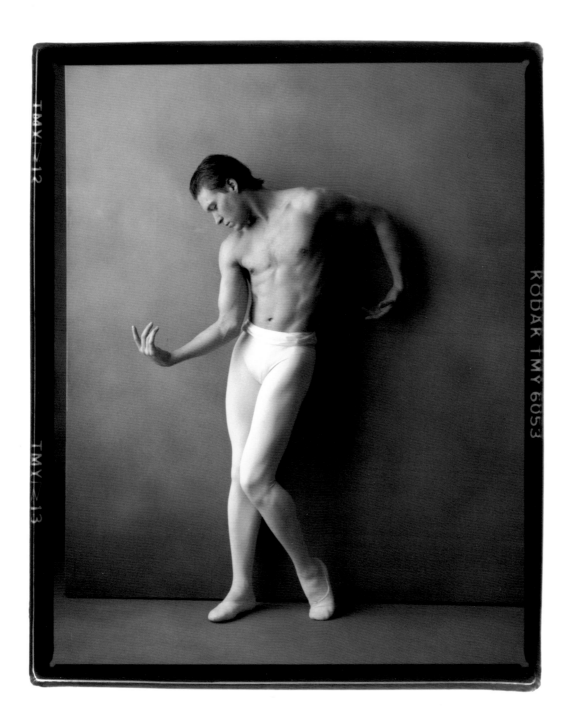

Robert La Fosse, New York City, 1990

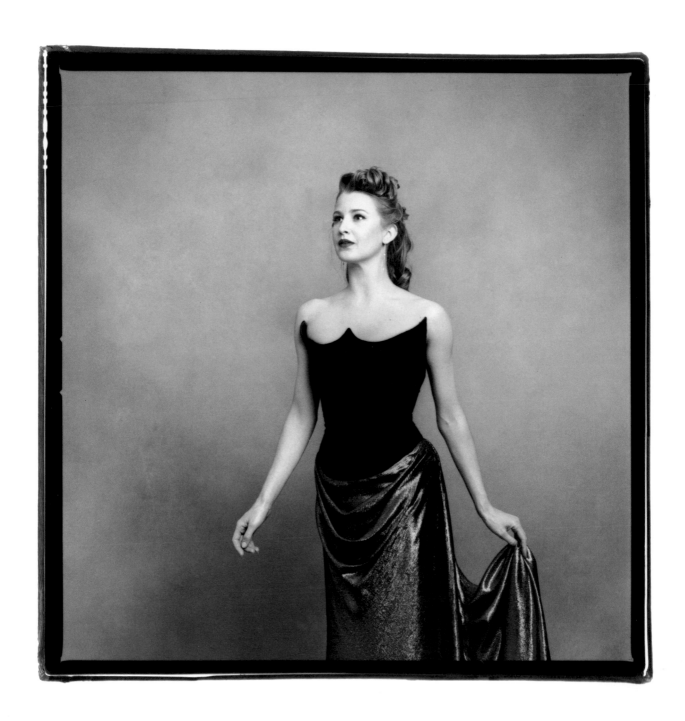

Darci Kistler, New York City, 1990
Robert La Fosse, New York City, 1990

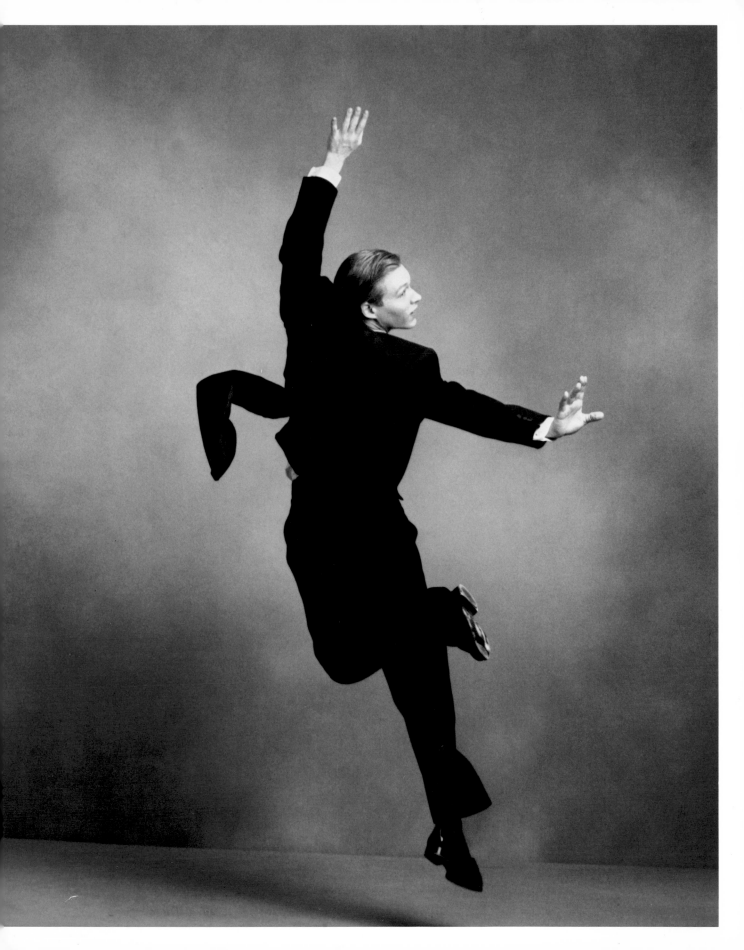

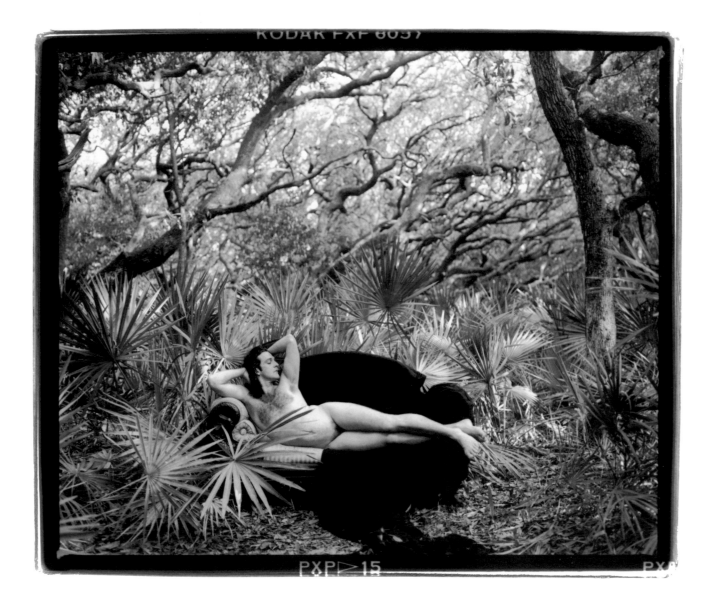

Mark Morris, White Oak Dance Project, White Oak Plantation, Florida, 1990

Mark Morris, White Oak Dance Project, White Oak Plantation, Florida, 1990
Mark Morris, New York City, 1989

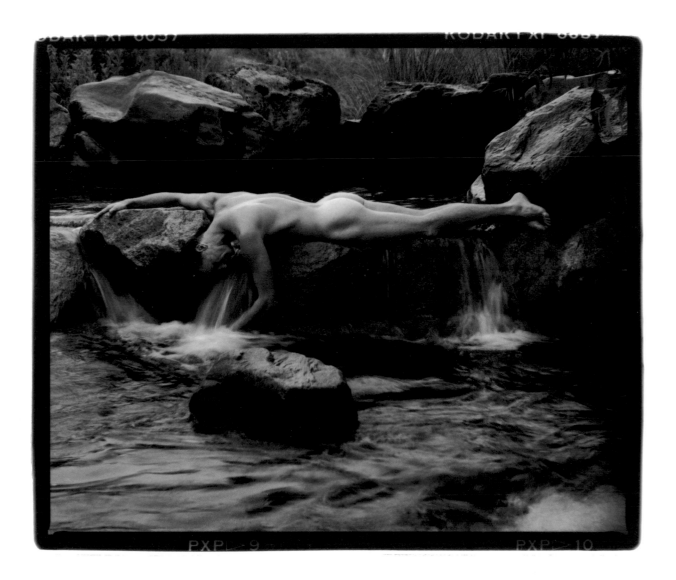

Rob Besserer, White Oak Dance Project, White Oak Plantation, Florida, 1990

Mikhail Baryshnikov and Linda Dowdell, White Oak Dance Project,
White Oak Plantation, Florida, 1990

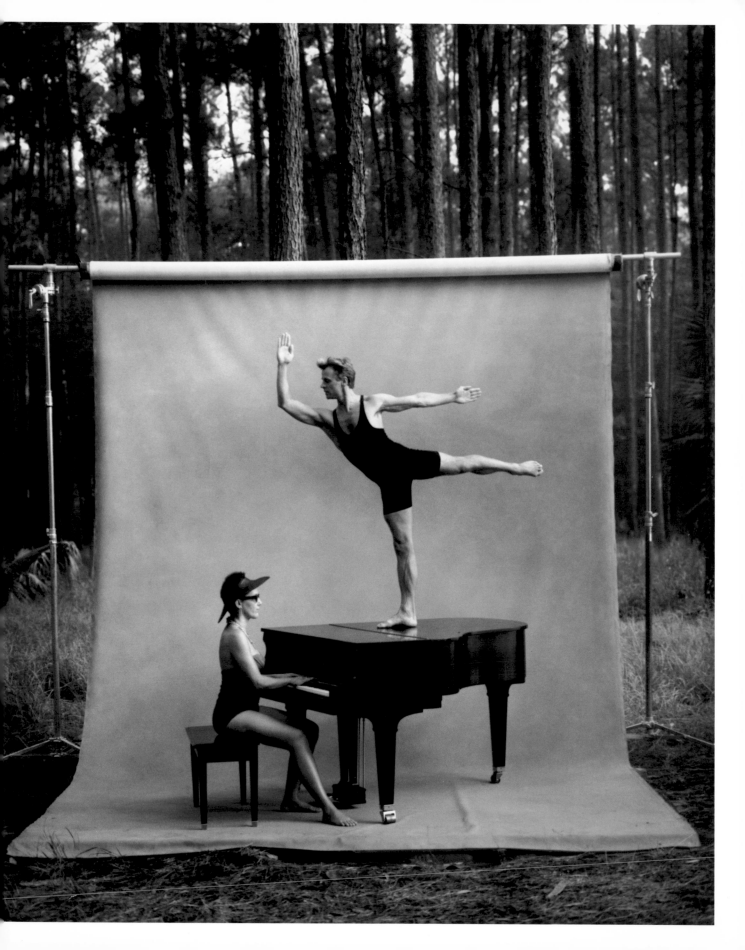

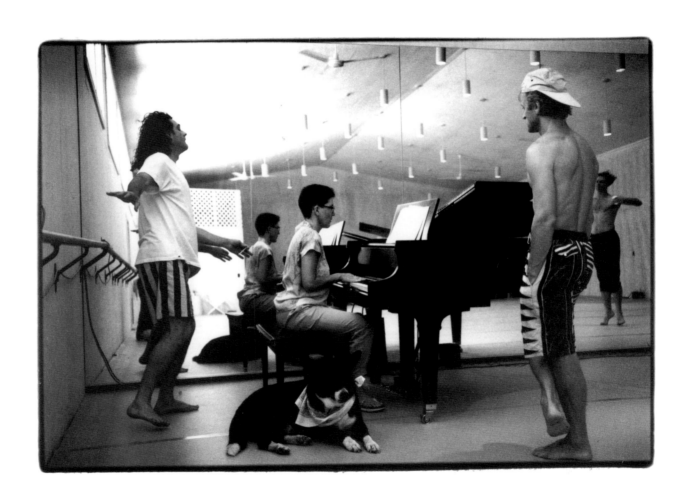

The following twelve photographs were taken at the
White Oak Dance Project, White Oak Plantation, Florida, 1990.

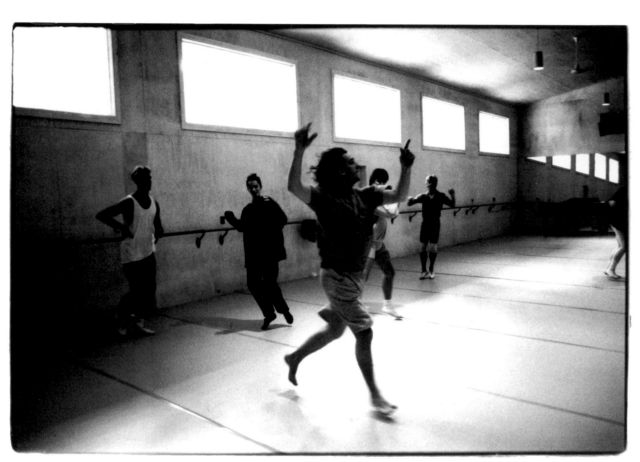

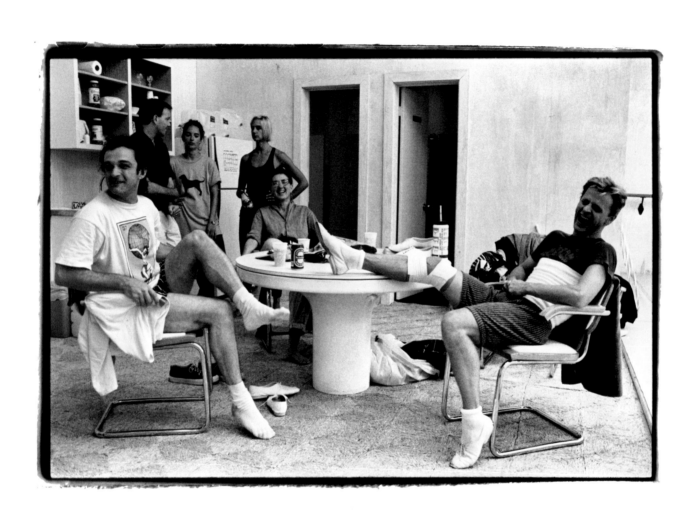

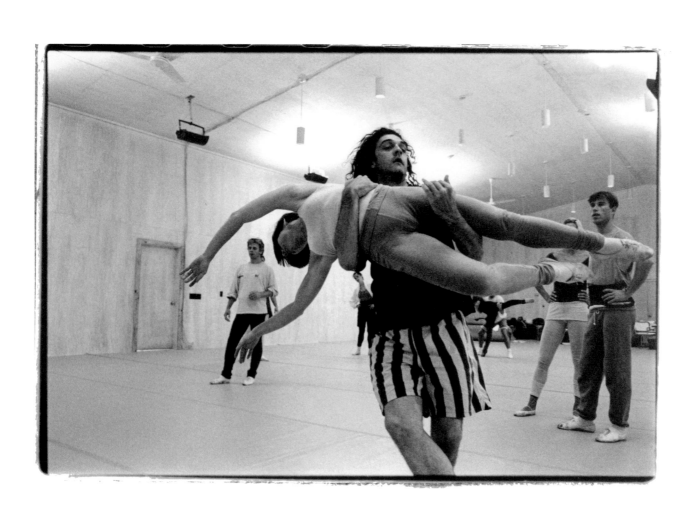

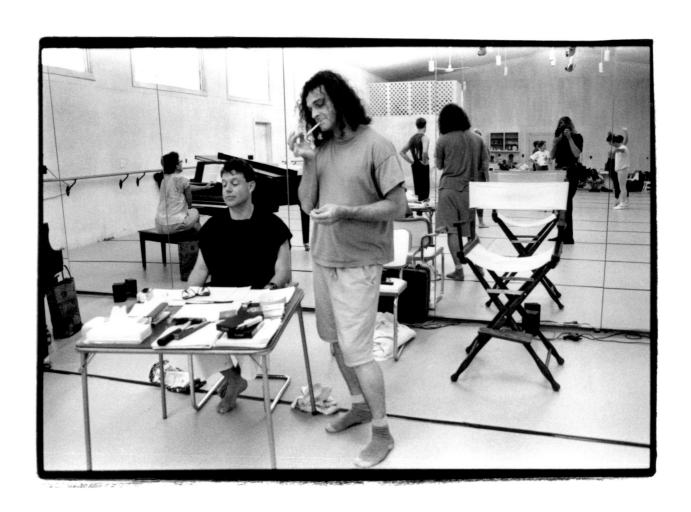

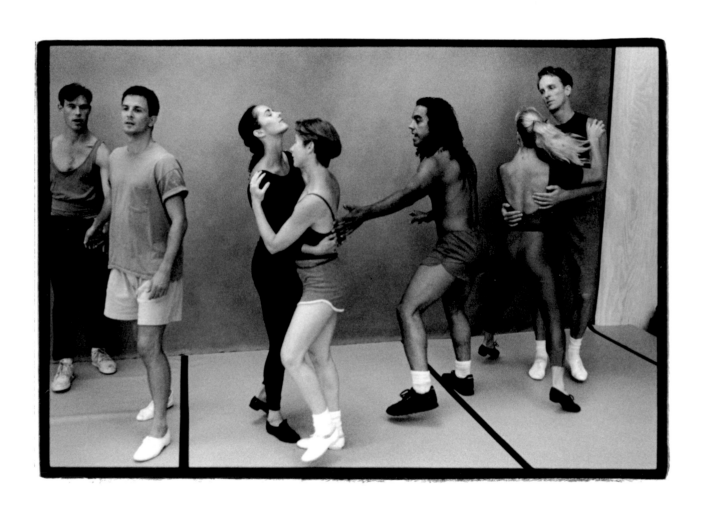

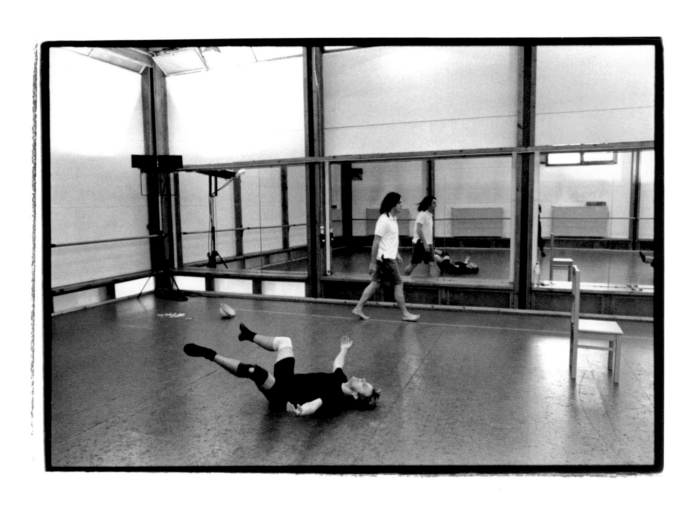

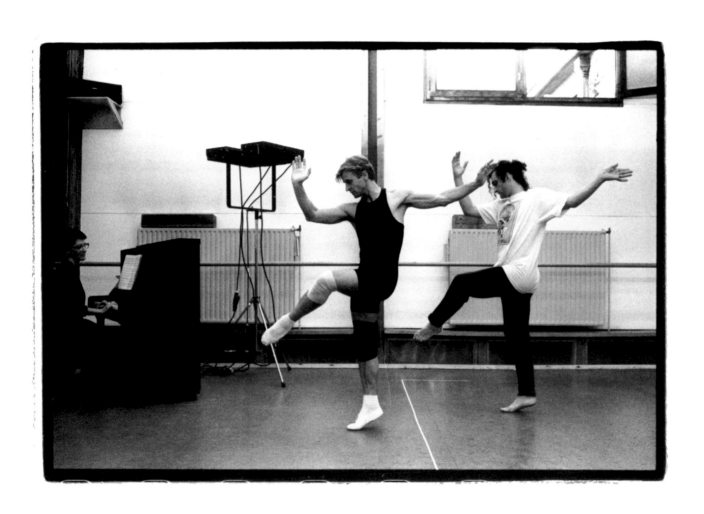

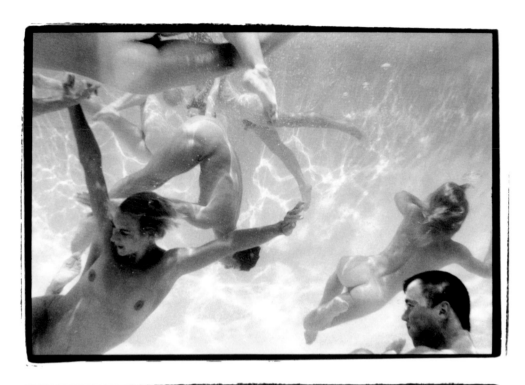

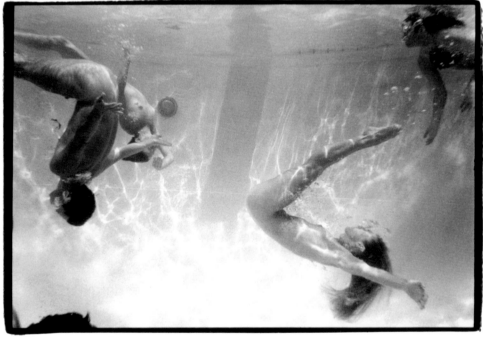

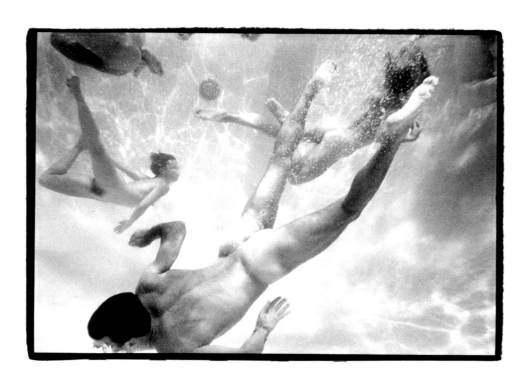

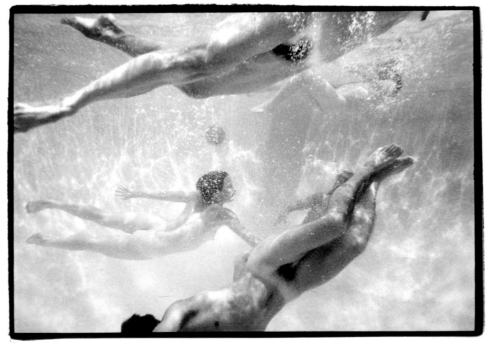

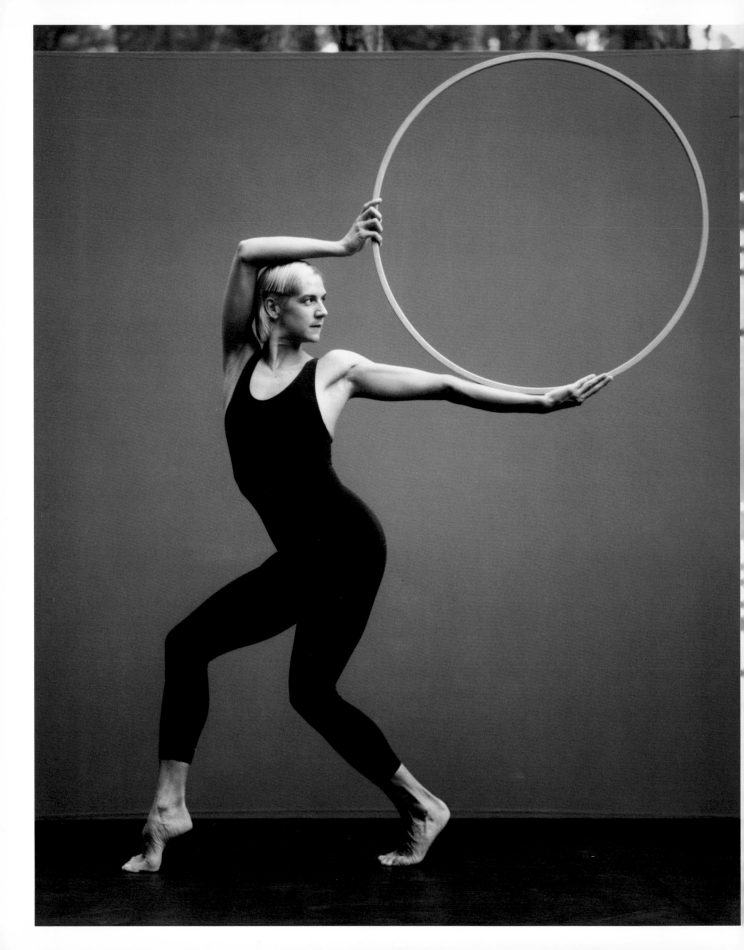

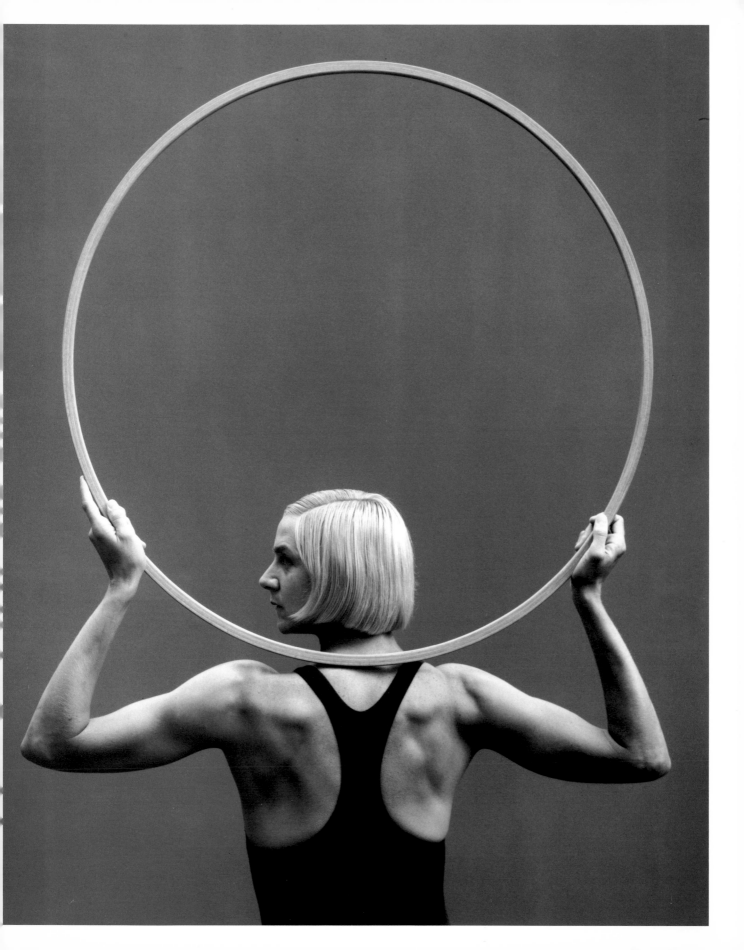

Preceding pages: both, Peggy Baker, White Oak Dance Project, White Oak Plantation, Florida, 1990
Twyla Tharp, New York City, 1989

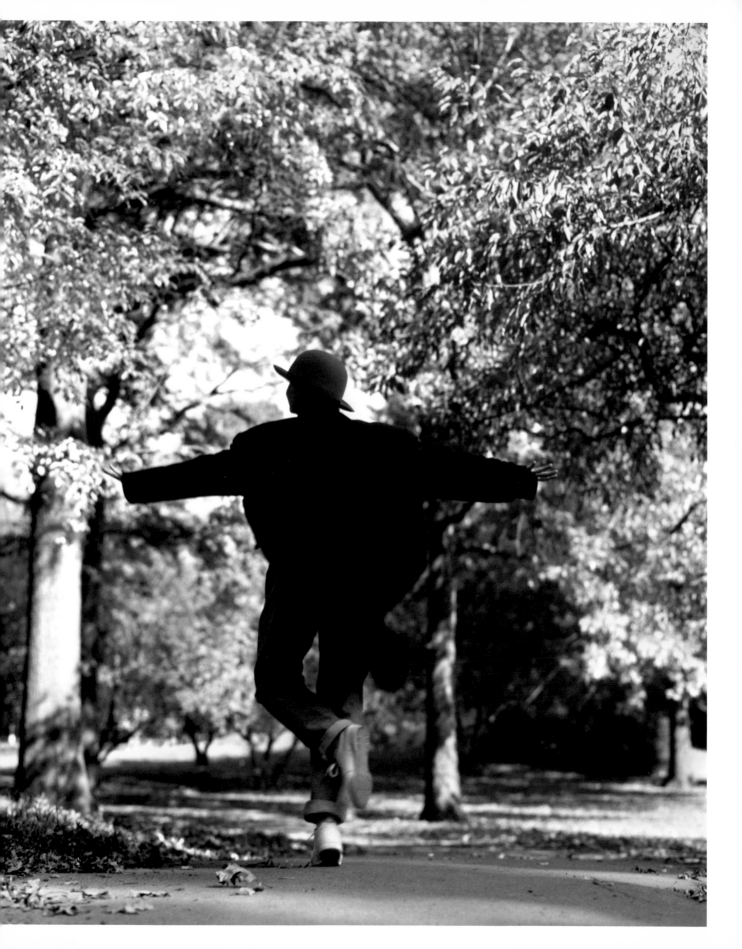

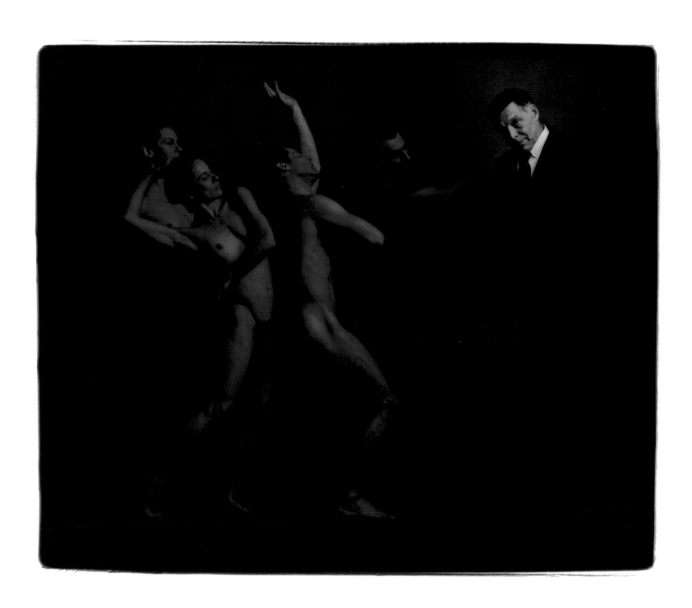

Paul Taylor with Kathy McCann, Kate Johnson, Christopher Gillis, and Elie Chaib, New York City, 1990

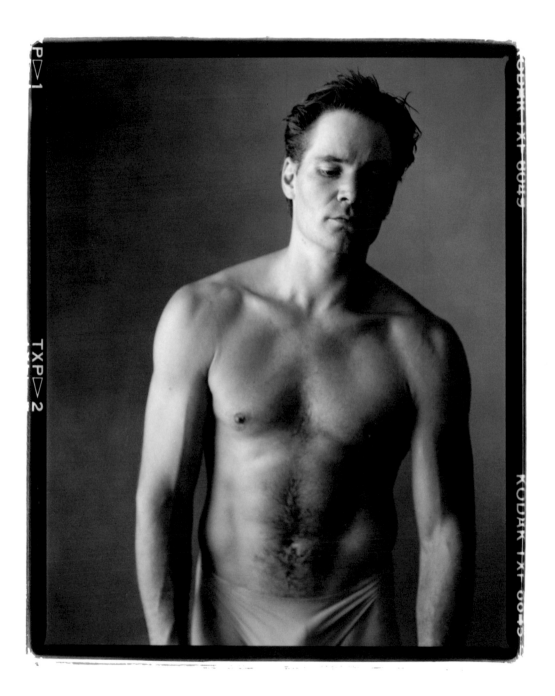

David Parsons, New York City, 1991

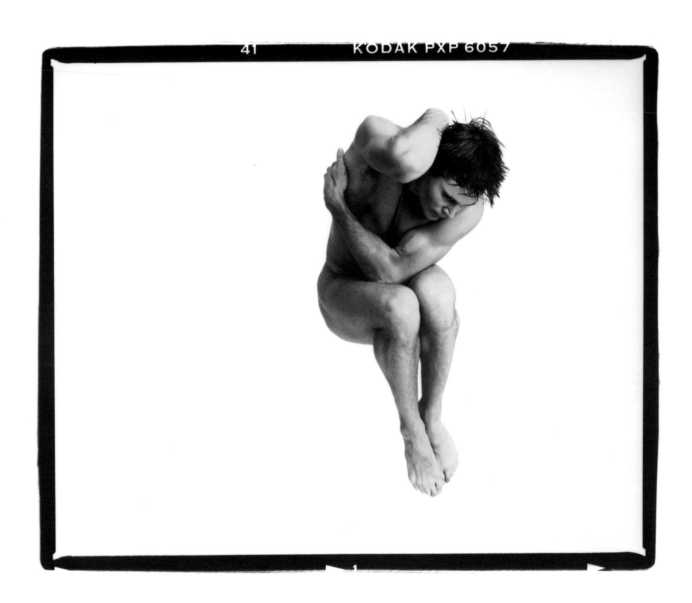

Both, David Parsons, New York City, 1991

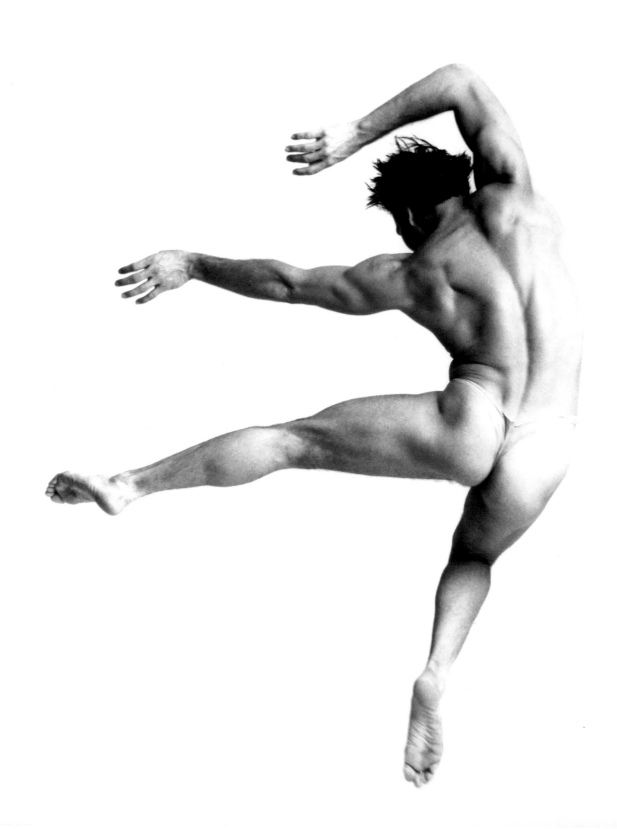

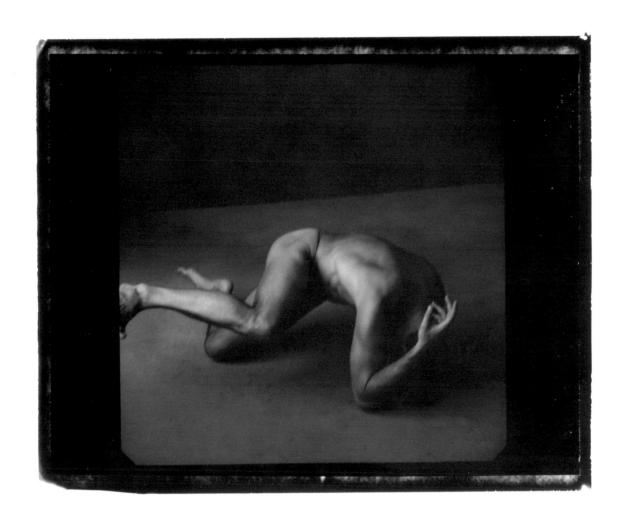

David Parsons, New York City, 1991

David Parsons, New York City, 1991

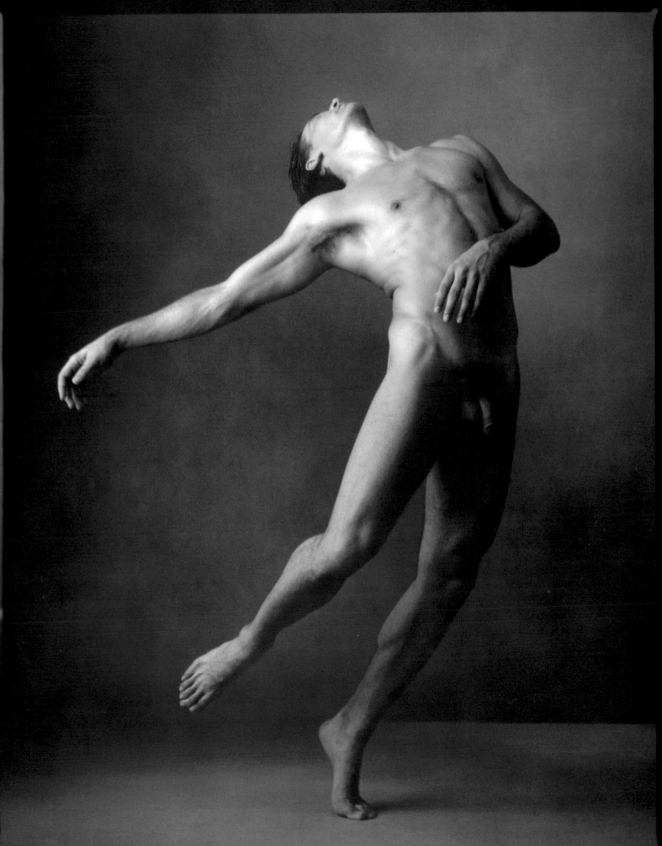

Annie Leibovitz

Annie Leibovitz, who since 1983 has been the main contributing photographer to *Vanity Fair* magazine, is one of the most widely known portrait photographers of her generation. In fact, like Edward Steichen in his day, and like such other contemporary photographers of famous personalities as Richard Avedon and Irving Penn, she has herself achieved a degree of fame that is on a par with many of those who sit for her camera. The list of celebrities she has photographed includes a Who's Who of popular music—Ella Fitzgerald, Mick Jagger, David Bowie, Bruce Springsteen, Michael Jackson, among others—as well as major figures in film, theater, art, dance, literature, sports, and politics.

Leibovitz was born in Waterbury, Connecticut, in 1949. As one of six children of an Air Force colonel, she spent her early years in different parts of the country. Leibovitz's career began in 1970 when, as a student of painting and photography at the San Francisco Art Institute, she submitted a portfolio of her photographs to *Rolling Stone* magazine. It's editor, Jann Wenner, impressed with her work and about to leave for New York to interview John Lennon, invited her along. Two photographs of Lennon made on that trip were used as covers. By 1973 she officially became the magazine's chief photographer, a position she held for ten years before moving in 1983 to the new Condé Nast magazine *Vanity Fair*.

Although initially using a 35mm camera loaded with black-and-white film and a photojournalistic approach to capture the counterculture, Leibovitz gradually moved into medium-format color and developed her own distinctive style, one that offered a refreshing break with conventional magazine portraiture. It has since been widely imitated. Highly conceptual and rich with narrative detail, her images are witty and invariably offer surprising visual metaphors that comment on the public personas of her subjects. While she photographs those who have achieved fame in the popular culture, she transcends the genre by offering a visual commentary on fame itself: more than merely capturing likenesses or even revealing character, she proposes interpretations. The resulting photographs themselves have often become haunting cultural icons: Whoopi Goldberg in a bath of milk, Meryl Streep stretching her whiteface mask, Lauren Hutton immersed in mud, the Reverand Al Sharpton in curlers. It is a tribute to the power of her work that her portraits have occasionally been considered shocking and even become the subject of controversy: a nude John Lennon clinging to a fully clothed, impassive Yoko Ono (taken just hours before his murder); and more recently, a nude and very pregnant Demi Moore, photographed for a *Vanity Fair* cover.

As creative, bold, and fearless as her images, Leibovitz is willing to take risks to capture a dramatic picture: while photographing Patti Smith in a warehouse, the experimental wall of fire she had set up fizzled, so she asked an assistant to set ablaze vats of kerosene behind the artist (whose back was slightly burned as a result). During a shoot of dancer David Parsons, Leibovitz climbed out on a gargoyle of New York's Chrysler building with her camera and stood in the wind, sixty-one floors above street level, to photograph her subject—who spread his arms, arched his back, and balanced on one foot atop a neighboring gargoyle.

Long interested in capturing the language of the entire body in her portraits—not just the face—Leibovitz has had a special interest in dance. She has photographed such performers and choreographers as Suzanne Farrell, Darci Kistler, Mikhail Baryshnikov, Paul Taylor and company, Merce Cunningham, and Mark Morris. In 1990 she was invited by Baryshnikov and Morris to document the creation of the White Oak Dance Project.

In addition to her editorial work, Leibovitz is known for many award-winning album covers and posters. In 1987–88 she was commissioned to take photographs for two major advertising campaigns: the "Portraits" series for American Express, and the GAP's "Individuals of Style" series. Both have been highly acclaimed; the American Express series was honored as "Campaign of the Decade," and received an award from the American Society of Magazine Photographers for "Innovation in Photography."

Leibovitz has had several one-person exhibitions of her work at the Sidney Janis Gallery in New York, and in 1991 she was given a museum exhibition of twenty years of her work, organized by New York's International Center for Photography in conjunction with the Smithsonian's National Portrait Gallery, which has toured widely in the United States and abroad. Her photographs have been published in *Annie Leibovitz: Photographs* (Pantheon/Rolling Stone Press, 1983), and *Annie Leibovitz Photographs 1970–1990* (HarperCollins, 1991). In 1983, on the occasion of the first exhibition of her work at the Janis Gallery, Andy Grundberg, critic for the *New York Times* wrote, "Miss Leibovitz qualifies as one of our most prolific and accomplished portraitists." In the intervening years her work has become both more conceptually innovative and more subtle in content, and she has been recognized internationally as an outstanding portrait photographer.

Technical Information

Leibovitz, who cites the skillful framing of Henri Cartier-Bresson as a major influence on her vision, began working for *Rolling Stone* in the early 1970s in a photojournalistic style using black-and-white film and a 35mm camera. When the magazine switched to color in the mid-1970s, so did she, working at first in 35mm. Because the rag paper of the magazine absorbed so much ink, she learned to make bold and graphic images using vibrant primary colors. Today she uses a Mamiya, a medium-format camera with a 2 1/4-inch negative, and Ektacolor positive film. She artfully combines strobe light with natural light for her portraits, whether she is shooting in the studio or on location. Her exhibition prints of color work are Cibachromes, and the black-and-white work is platinum and gelatin-silver prints.